Bar and Ger

A drama in one act

Geraldine Aron

Samuel French—London
www.samuelfrench-london.co.uk

Please see page iv for further copyright information

BAR AND GER

First performed at Brian Astbury's Space Theatre in Cape Town, South Africa in 1975.

Ger Yvonne Bryceland
Bar Wilson Dunster

Designed and directed by Walter Donohue

AUTHOR'S NOTE

Bar and Ger is the story of a brother and sister, Barry and Geraldine. At the beginning, Ger is about ten years old and Bar is newly born. They age gradually – not necessarily at the same time – until Bar is seventeen.

A good convention for this short play is to have the characters sit, kneel and recline against two giant cushions propped against a low rostrum. A carpet under the cushions is comfortable for the actors. They should wear simple, timeless clothing. Their movements should be slight and symbolic without any big theatrics. Sometimes they touch or interact, but mostly they are separated by time and place.

Three dots (***) indicate a change in time.

Luigini's Ballet Eygptien makes a good overture and can be played again at the end.

GLOSSARY
Marmite, a sandwich spread
Eleven Plus, an exam at the end of primary school
Earl's Court, an arena for military displays, etc
Andrew's Liver Salts, like Alka Seltzer
Pillion, the passenger seat on a motor cycle

As the lines are often rhythmical, do not substitute words unless absolutely necessary. The name Ger is pronounced with a "J".

Geraldine Aron

To beloved Brigi, my friend and younger daughter

BAR AND GER

The play begins in darkness

Luigini's Ballet Eygptien is a good choice for opening and closing music

Bar Knock knock.
Ger *(bored)* Who's there?
Bar Marmite!
Ger Marmite who?
Bar Ma-might-have-a-baby!

Ger groans

Bar He he he he he.

<center>***</center>

A spot grows until Bar and Ger are encircled by a ring of light. Bar is curled up like a baby. Ger leans on her elbow, looking down at him

Ger Little mite with big red face
 Blonde head and bawling mouth.
 What do you think of London?
 I'm not so sure I wanted a brother
 but Dad's delighted
 though I'm sad to say
 you'll be a five minute wonder
 like his three daughters were.
 Yuk! I hate feeding babies mashed potato.

<center>***</center>

Ger sits upright, looking downstage. Bar leans on his elbow and looks at her

Bar I saw my sister on a horse
showing off and waving
She wouldn't take me 'cos she
wanted to canter
but she gave me a small red truck instead
I won't wave back or she'll think I like her.
Anyway, she's gone round the corner now.

<div align="center">***</div>

Ger I told my brother Bar he was adopted.
(*To Bar*) Where do you think your blonde hair comes from?
Bar (*furious*) You're adopted yourself, you rotten liar —
Where do you think your big nose comes from!
Ger Then he punched me — as hard as he could
and wouldn't let me hug or kiss him all day.
Wish I'd never said it now.

<div align="center">***</div>

Bar sits cross-legged, his back to Ger. Ger looks innocent

Bar The Mother Superior is gonna kill me at 4 p.m.
When I have to report to her office,
privately.
Because my sister Ger was supposed to
have "helped" me with my homework.
The silly cow spelled everything wrong —
and put Belfast as the capital of Ireland.
And the Mother Superior will be waiting
at 4 p.m.
Thanks very much for nothing.

<div align="center">***</div>

Ger Bar told me a joke,
 about Edmund Hilary climbing Mount Everest:
Bar This penguin saw Edmund looking lost,
 and said: "If you're looking for the top peak —
 I'm sitting on it!"
 (*He makes penguin-like movements*)
Ger He pretended he'd made it up himself,
 When in fact it appeared in a book of cartoons.
Bar Ger wrote this poem, which I happened to see,
 when I happened to look in her drawer:
 "I love Deputy"
 Deputy is big and strong
 his mane and tail flow white
 he has a bold and handsome eye
 his coat shines in the night
 Only Miss Bruce can ride him
 I'll never have a hope
 unless — ha ha — they tie me on
 with big strong lengths of rope.

 Yecccchhhh!

<div align="center">***</div>

Ger I get two pounds, fifty-one pence a week
 My older sister gets five pounds
 My younger sister gets two pounds fifty
 So I should get *three twenty-five* by right
 But Dadio's never liked me —

Bar interrupts, drumming and singing a Pepsodent jingle. (You can hear it on YouTube)

Bar "You'll wonder where the yellow went,
 When you brush your teeth with
 Pepsodent."

Ger My brother Bar gets nothing at all
 but why should *I* give him anything
 if my sisters don't?
Bar (*singing his version of the jingle lyric*)
 You'll wonder where your teeth have gone —
 when you brush 'em hard with atom bomb!

<div align="center">***</div>

Bar and Ger link arms affectionately

Ger Bar appointed himself —
Bar Chief Medical Officer for the Family

Bar salutes

Ger He put two bandages and a jar of
 Vaseline into a tin box
 and waited hopefully for a casualty.
 Mom cut her finger,
 and,
 absentmindedly,
 went next door for a plaster.
 Bar was furious when he saw it,
 absolutely *pale* with frustration, in fact.
 He put his first aid kit
 straight into the dustbin
 and gave up medicine forever!

<div align="center">***</div>

Bar My sister Ger had a jumble sale
 on Saturday
 Her and her friends collected old clothes
 and toys and stuff
 and made out it was in aid of cancer research,

but they kept half for themselves.
I was in charge of the door of the hall
and got two pounds for helping
and two pounds for keeping
my mouth shut about
you-know-what.

<div align="center">***</div>

Ger One winter's day, at ten past five
we decided we'd learn to play Scrabble.
Bar flew down to the High Street,
without even a coat.
But when he got to the toyshop
the lady said
"Sorry, sonny, we've just cashed up.
Save your money till Monday."
He came home all humpy
and purple with cold —
Bar Hag
Ger Bag
Bar
Ger } (*together*) Rotten ole slag

*Ger kneels and does something lyrical and balletic with her arms and
upper body*

Bar Ger thinks she's a famous ballerina or somebody
Her hair in a bun
her nose in the air
practising in the dining room
to the same old record.
I get a good view through the
hatch in the wall
and just when she thinks she's
terrific, I sing it:

*Bar waves his arms about and sings to the melody of the opening of
Luigini's Ballet Eygptien*

Bar "Cold meat balls are highly indigestible
unless you eat them covered in cheese.
Cold meat balls are highly indigestible
unless you eat them covered in cheese."

Ger strikes a new ballet pose

Ger was in a ballet at Fulham Town Hall
Seven pounds fifty to get in!
Ger took the part of a man in a kilt
and got quite a few claps at the end.
After the show I saw her up close —
brown stuff on her arms
Big red lips
Mom said it was great to be let in back stage —
but all I could smell was feet.

Bar and Ger lean back on the cushions, their feet downstage

Ger I'll never forget the day Dadio thumped me —
so hard I fell off my chair
And when I reached the floor
under the table
I just stayed there
pretending I'd fainted.
Unfortunately, on instructions from Dadio
I was completely ignored
and would've died of starvation
except that —
Bar Bar passed down a Marmite sandwich.
Ger Good old Bar
I really enjoyed it

Bar and Ger sit up, back to back

Bar The doorbell rings —
Ger (*whispering*) Who is it, Bar?
Bar A man from a carpet cleaners'
 (*After a pause*) The doorbell rings —
Ger Who is it, Bar?
Bar A man selling dusters and tea towels
 (*After a pause*) The doorbell rings —
Ger Who is it, Bar?
Bar It's nuns, collecting money.
 (*After a pause*) The doorbell rings —
Ger Who is it, Bar?
 (*After a pause*) Who *is* it, you brat?
Bar (*disdainfully*) It's George.
Ger (*all smiles*) Why, George, what a lovely surprise!
Bar Huh — I said — and screwed up my eyes.
 (*Singsong*)
 Chinese.
 Japanese.
 Dirty knees (*He points at his knees*)
 Look at these! (*He presents his chest*)

Ger jabs him with her elbow

They sit back to back

Bar My sister Ger thinks she a big shot now
 because she's got a fella called Ron.
 You shoulda seen them necking last night —
 outside, in his ole crock.
Ger Last night I had a real fight with my brother Bar —
 Caught him snooping out the window
 at me and Ron in the car.

Bar She would've taken me to the flicks
 if it hadn't been for him.
Ger And he has the nerve to say Ron is stingy —
 because Ron never slips him anything
Bar All that kissing and stuff makes me feel sick.
Ger Imagine! A nine year old brat *snooping* at a person!
Bar Really sick.
Ger That kid needs a good kick in the pants at times.
Bar Sick.
Ger (*after a pause*) Still, hope he didn't get the wrong impression.

<div align="center">***</div>

Bar "Hello little man, is your big sister in?"
 Well she is if you're Arnie, but not if you're Tim.

Ger thumps him

 "Well, little man. And what else did she say?"
 No. She definitely isn't in.

Ger rolls her eyes in despair

<div align="center">***</div>

Bar Ger got a letter from Henry
 which, unfortunately,
 she left on the side of the bath.
 It says —

Ger covers her ears

 "I've never felt lips as soft as yours,
 my darling"
 and
 "it won't be long now before we're

together in Cape Town."
When she gets home from work I'm gonna
ask her if she's gonna marry King Kong!
(*He beats his chest and grunts*)

Bar and Ger lean back, facing downstage

Ger When Dadio orders tea
 he wants it fast —

They sit up, comically alert

You can tell by the tone of his knock on the floor.
Mom makes haste to the kitchen
and Bar obliges

Bar puffs out his cheeks

by blowing the kettle's whistle
till his cheeks are ready to burst!

They fall back, laughing. Then Ger sits up

Can't make up my mind about Henry.
Barry quite likes him
and he was right about Ron — talk about stingy!
On the good side,
Henry loves me and will
"take me away from all this"
But who'll stand up for Barry when I'm gone?

Ger lies back, using Bar's lap as a pillow. His head pops up

Bar Ger *kissed* me when I passed my Eleven Plus
 in front of all my mates —I could've killed her.

Even Mom waited till we were home.
Still, Ger bought me a new fishing rod
and she's giving me a lift to the river
on her Vespa
at 5. a.m. in the morning!
Ger (*snuggling down*)
This is the warmest bed I've ever been in —
thanks to the electric blanket I treated myself to.
Bar And she's giving me a lift to the river —
on her Vespa,
at 5 a.m. in the morning.
Ger Bar came into my room
at *4.45* a.m.
Demanding a lift to the river, if you please.
It wasn't even light outside.
He went off on foot, in a huff.
He must be out of his mind waking me up
at that hour.

Bar turns his back. Ger sits up and looks at him

Anyway, I gave him the rod, didn't I?

They lie back, curled up together

Ger Dadio's up to his tricks again,
hit Mom this morning for no reason at all.
Poor old Bar jumped up and defended her
like a real man — and got a red ear for his trouble.
He cried in my room.
Bar (*softly*) Why aren't we a happy family?
Ger I didn't know what to say.
I just didn't know what to say.
So I gave him a Fruit and Nut.

Bar Sorry. Sold out. No tickets left.
 The whole of Earl's Court is full up.
 Ger goes up to a soldier, on guard at the gate.
 She whispers to him
 and next thing we're in
 free seats near the Royal Enclosure!
 When I asked how she'd done it
 on the way home
 she said —
Ger (*airily*) Just told him it was your birthday.

<p align="center">***</p>

Bar My sister Ger is keen on drinking
 Andrews Liver Salts
 But not like a normal person would.
 She says ——
Ger To get the full benefit, you have to drink the mixture
 while it's still effervescing.

Ger mimes drinking the seltzer. Bar imitates her

Bar So she drinks a whole glassful in one mighty
 swallow — bubbles bursting in her nose

Bar grabs his chest, his throat

 Then she staggers and gasps and wheezes
 and chokes — says it gives her the skin of a rose.

Ger caresses her own cheek. Bar mockingly caresses his

<p align="center">***</p>

Ger (*happily*) Well. I've made up my mind
 and Henry's the one.
 We'll be getting married in Cape Town

Mom's got the blues that it's so far away —
Dadio doesn't really mind.

Bar } *(together, gruffly)* "If you don't get out —
Ger } I'll *throw* you out!"

Ger My sisters took off years ago.
 Well Bar, you're on your own now, kid.
Bar *(sadly)* You'll wonder where your teeth have gone
 when you brush 'em hard with Atom Bomb.

<center>***</center>

Ger Had a very nice letter from Bar today
 covered in oily fingerprints.
 He bought a motorbike from an actor
 nobody's ever heard of
 and says:

Bar extends his arms and legs as if astride a motorcycle

Bar You haven't lived till you've
 driven through Heathrow tunnel at
 90 kilometres per hour!
Ger Mom's hair must be grey with worry
 but secretly, I agree that ——

She extends her arms and legs

Bar } *(together)* You haven't lived till you've
Ger } driven through Heathrow tunnel at
 90 kilometres per hour!

Ger He's crazy, that brother of mine.
Bar My sister Ger is really screwy.
 When I think of the money she wasted
 phoning me all the way from Cape Town
 to deliver a lecture:
Ger Motorbikes are too dangerous —
 hang on and I'll buy you a Mini

Bar You'd have sworn she was speaking from
down the road.
Nag. Nag. Nag.
"Ger," I said, "I've got my licence.
What time is it down there?"
She's nuts, that sister of mine.

<div align="center">***</div>

Bar Ger's coming home on holiday
hubby in tow.
Mom's counting on her to talk me into
selling my bike.
Hah!
If I know Ger she won't be able to keep her
hands off it.
I'm gonna take her for a ride that'll make her
hair stand on end.
Wonder if old Henry will have the nerve
to go pillion?
Ger After four years
Coming home feels funny
Everything looks so small and grey
Even Mom looks small and grey
New curtains.
But Bar is the biggest surprise of all
six feet tall and very mod —
still has the black fingernails.
And there's a girlfriend lurking
in the background.
Bar My sister Ger is getting old.
Skinny as a scarecrow ——
Ger Bar is shy
Bar Nose as big as ever ——
Ger Bar is danglified
Bar Brown from Africa
Ger Bar has pimples

Bar The husband has never even *heard* of
 garage, house or hip hop! But Ger had a go on my bike.
 She's not a bad ole stick.
Ger He shaves twice a week — he's nearly a man.
 (*After a pause*) "Cold meat balls are highly indigestible —
Bar ⎱
Ger ⎰ (*together*) "unless you eat them covered in cheese!"

Ger puts her arm around Bar's shoulders

Ger The night before we returned to Cape Town
 we treated my family to
 Fiddler On The Roof.
 Bar and I laughed at all the wrong parts.
 Afterwards, at dinner, Bar bought us
 Mateus Rosé
 which the waiter spilt.
 Bar blushed for the waiter
 and I blushed for Bar
 and felt sad all evening

Bar and Ger draw apart until only their hands are touching

Bar Ger and I said goodbye
 in the middle of the hill.
Ger And then we walked on down.
Bar And I walked back up.
 Each time I waved
 they were smaller and smaller
 Till they came to a part where the street light was out
 and vanished completely
 luggage and all.
 I gave just one more wave though
 in case Ger was looking.

Their hands lose contact

Ger We came home one Sunday
 and found a little slip of paper,
 under the door
 near a nice clean milk bottle.
 It said:
 "Please phone the police station, Madam."
 so we did
 and they said:
Bar "Sorry, but Barry is dead."

Bar moves back until his head is out of the light

Ger It must be a mistake —

Ger turns to look back at Bar, desperately

Bar "Sorry, but Barry is dead."
Ger Of *course* it's a mistake.

*Bar bows his head and remains still until the play ends. Ger sits between
his legs, using his knees as the armrests of the seat of a plane*

 My heart has been thumping since I left Cape Town —
 didn't sleep a wink on the plane.
 I know I will burst when I reach home.
 But no, everyone is smiling bravely
 and nudging each other to keep smiling bravely
 for Ger's sake.
 Aunt Della, my favourite,
 is in charge of the tea-making.
 She says:
 "Don't get a shock,

but they shaved off his hair in Casualty
and he doesn't look himself."
But she needn't have bothered
because I don't want to see Bar dead —
with or without the blonde hair.
I go into Bar's room
which seems sunny because of his yellow curtains.
I hide in the darkness of his wardrobe

Ger puts her cheek against Bar's knee

I can smell him on his clothes.

She sits up

Dadio sticks to his room
and plays heart-breaking opera
so everyone will know
he is genuinely sad
about his only lad.

I went for a walk on Putney Heath
and when I got to the middle
I sat on a tree trunk and said
(*softly*) Barry?
(*Loud and anguished*) BARRREEEE ...
and held my breath expectantly,
frightened to blink.
The only thing that appeared
was a policeman on a horse —
and the funny look he gave me!
Had to pretend I was practising a song
and gave him a casual wave.

You should've seen the turnout and the flowers.
And that plump, jolly undertaker

putting on a sad expression.
Bar would have laughed.
And Auntie Ivy — all dressed up —
sitting herself in the priest's car by mistake
and having to be ejected.
All our friends and neighbours are crying
but I can't seem to cry at all.

That's that, little Bar.
Please don't be lonely
please don't be frightened
and sorry about the time
I promised to take you fishing
and changed my mind.

<center>***</center>

*Ger lies back, still between Bar's legs. She gazes upwards. The light
begins to fade. A slatted-effect gobo creates a perfect mood*

When we go to bed in Cape Town
our bedroom is completely dark
except for a small disc of light on the ceiling
(caused by a bent slat in our Venetian blind.)
On windy nights it dances
on calm night it is steady
But it never goes away.

I call it Bar's light.

*The fade continues to black-out. If music is included, it should not
commence for about six seconds*

PROPERTY LIST

On stage: 4 giant-sized cushions (pillows) leaning against a rostrum*

*If the play is set on a raised stage, the rostrum has to be pretty high, as the characters sit down all the time. It's also nice to use a small carpet (rug) under the cushions. The idea is to create a cosy nest of cushions for Bar and Ger

LIGHTING PLOT

Property fittings required: nil

The same scene throughout

To open: Darkness

Cue 1 **Bar**: "He he he he he." (Page 1)
Bring up spot on **Bar** *and* **Ger** *until they are encircled in a ring of light*

Cue 2 **Ger** lies back, between **Bar**'s legs (Page 17)
Start slow fade to black-out

EFFECTS PLOT

Lightning Source UK Ltd.
Milton Keynes UK
UKHW021856130122
397110UK00005B/195